Hotel Carpets
Bill Young

HOXTON MINI PRESS

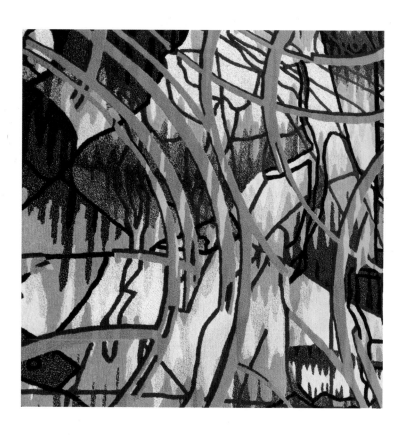

The carpet I helped design with Marriott and Royal Thai

Pilot's Note

My Instagram bio is neither verbose nor proper grammar. It is, however, painfully accurate: *I travel for a living. Stay in a lot of hotels. See a lot of carpet.*

I've been a pilot for the last 30 years, starting out in the Navy and currently flying posh business aircraft all over the world. I often find myself in hotel lobbies looking down at my phone while waiting for fellow crewmembers so we can find a proper meal somewhere. It was during one of these times when I realised that the carpet beneath my feet was unusually festive. I took a picture with my phone and soon my Instagram account, @myhotelcarpet, was live. It wasn't until a year later that my daughter Jill took it upon herself to promote my pet project and my number of followers exploded.

With this came a lot of media attention. I also got to visit Marriott HQ and be a small part of the design process of a carpet for their new Austin location (pictured opposite). I haven't attempted to cash in on the carpet fame. I'm a bit lazy and have no idea how to do it without looking like a huge sellout. I'll stick to flying and continue to share the carpets I come across.

Welcome aboard, fasten your seatbelt, be nice to the flight attendants, sit back, relax and enjoy the flight.

Bill Young

Daughter's Note

Few things are as omnipresent and forgettable as carpet. It takes up hundreds of square feet in our homes but nearly no space in our minds, unless some poor dog or mother-in-law spills a glass of pinot noir, turning the living room into a sad Jackson Pollock. Perhaps this is why the Hotel Gods, when they convened one holy day, decided that the carpets gracing their guests' feet would be anything but boring.

As a young child, I found few things more exhilarating than running down the patterned corridors of a hotel, dodging the pink diamonds and stepping on every yellow circle. I swear I've never run faster than those times, speeding out of an elevator and ignoring my parents' frustrated calls. I was like a less-terrifying version of *The Shining*'s Danny Torrence, hypnotized by a maze of carpet.

Though I'm older now, and can mostly resist the urge to sprint when I see a patterned floor, I remain entranced by the intricate and often ridiculous details of hotel carpets. When my dad, a traveller by nature and career, began to document the carpets he encountered on his many trips, I knew he'd happened upon something special. I admired this carpet compilation – displayed for the world via a meager 80-some-follower Instagram account – for about a year, thinking with every new post that more people deserved to enjoy my dad's creation.

When I tweeted about his page in November 2018 (boldly proclaiming to the abyss that 'All I want for Christmas is for my dad's carpet Instagram to go viral') I was blown away by the amount of public excitement it immediately received. Within three days, almost half a million people were following my dad's account. Soon we were being interviewed by BuzzFeed and international travel sites. It was a whirlwind brush with internet fame.

The carpet pictures aren't just fun – they're a testament to the wild and wonderful things all around us that we often ignore. In documenting them, my dad has found a way to ignite appreciation and excitement. So enjoy these curated carpets, and the strange beauty of what lies just under your feet.

Jill Young

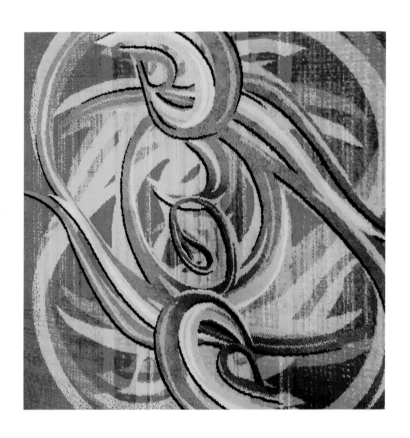

Marriott Cincinnati Airport, Cincinnati OH, USA

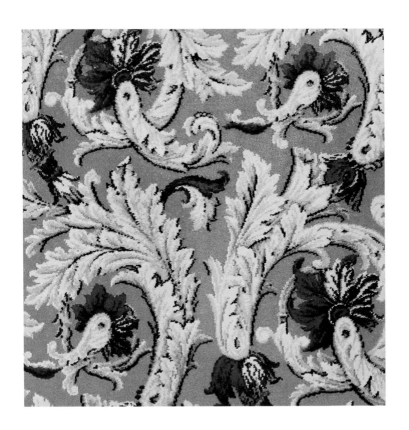

Nagoya Marriott, Nagoya, Japan

As a corporate pilot I've laid over
in Las Vegas A LOT. I've stayed in about
every hotel on the strip, from the good ones
to the 'OMG what is that stain on the towel
from?!'. (Two nights there.) The Cosmopolitan
is my favourite Vegas resort. Insider secret:
there is a hidden speakeasy on the second
floor behind an exit sign. Look for the
donkey on the door.

The Cosmopolitan of Las Vegas, Las Vegas NV, USA

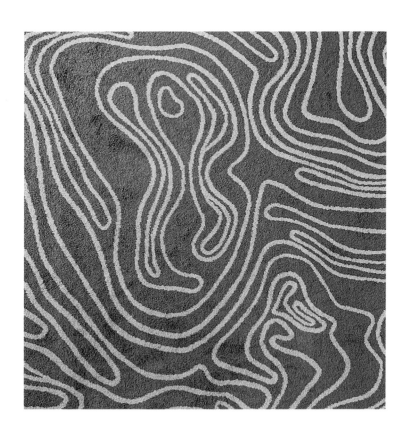

Le Méridien Munich, Munich, Germany

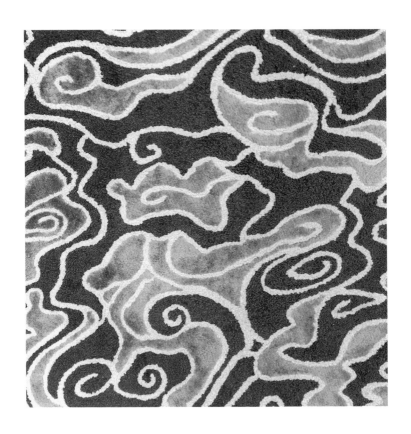

JW Marriott Hotel Beijing, Beijing, China

The Cosmopolitan of Las Vegas, Las Vegas NV, USA

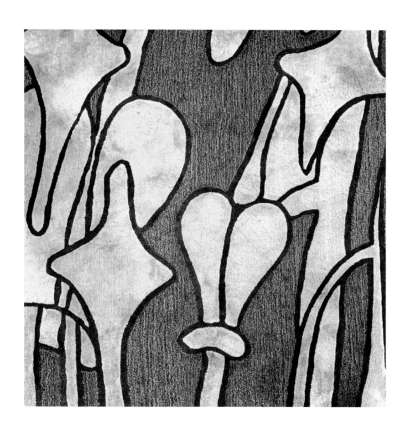

Marriott's Grand Chateau, Las Vegas NV, USA

I found this lobby carpet in the LAX Marriott while waiting for a crew member. I was holding my grande vanilla latte (nonfat) in my left hand while I took this with my right. We were about to fly all night to Sao Paulo, Brazil. I'm pretty sure my hotel in Sao Paulo didn't say 'Sao Paulo' on the carpet. It must be a California thing.

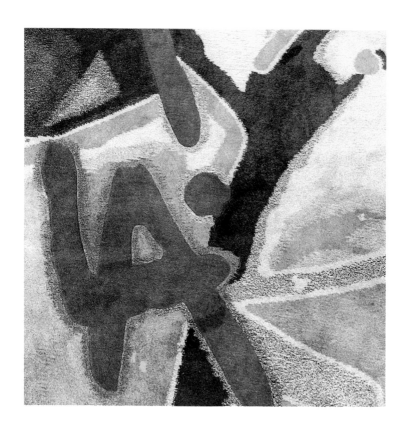

LAX Marriott, Los Angeles CA, USA

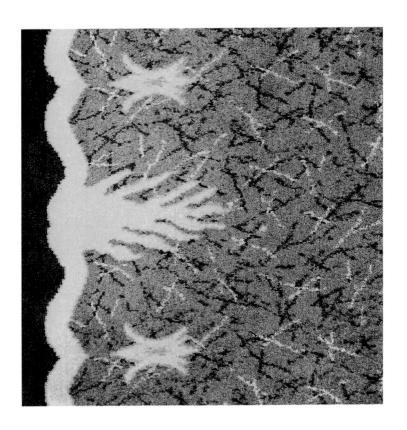

Rotterdam Marriott, Rotterdam, Netherlands

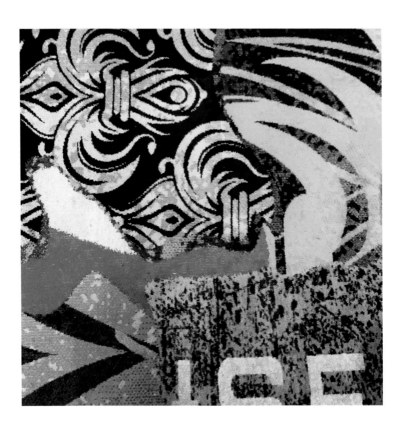

The Cosmopolitan of Las Vegas, Las Vegas NV, USA

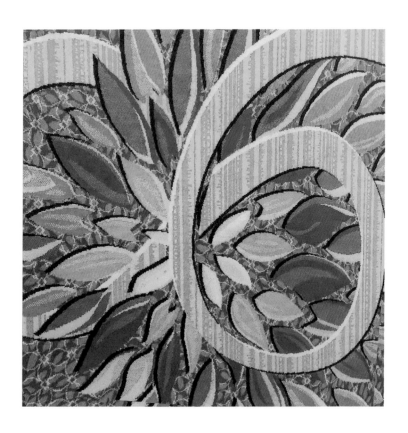

Marriott Cincinnanti Airport, Cincinnati OH, USA

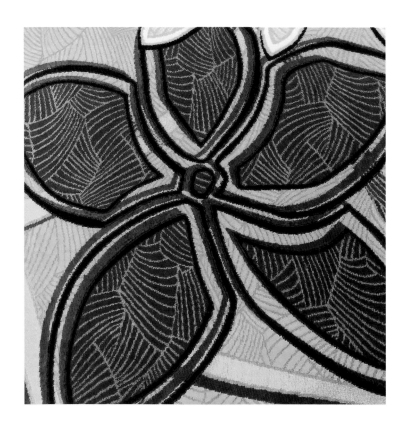

Teaneck Marriott at Glenpointe, Teaneck NJ, USA

I've probably spent a year at the Nagoya Marriott. They know me by name. The hotel stands majestically over the city of Nagoya and the views are spectacular. I'll never tire of them. Although I will of this carpet.

Nagoya Marriott, Nagoya, Japan

Courtyard by Marriott Tokyo Ginza, Tokyo, Japan

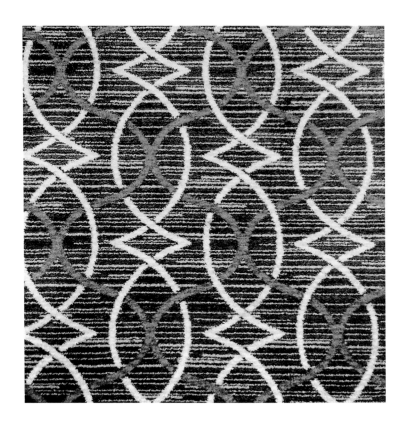

Sheraton Ann Arbor Hotel, Ann Arbor MI, USA

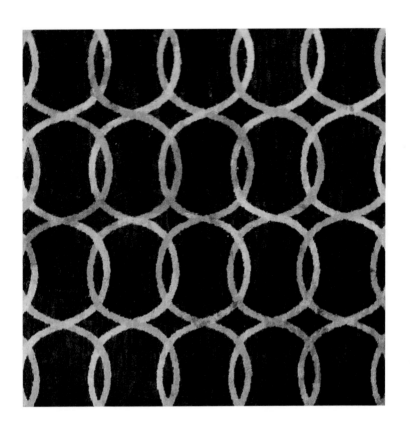

Canyon Creek Country Club, Richardson TX, USA

Fairfield Inn & Suites Austin North, Austin TX, USA

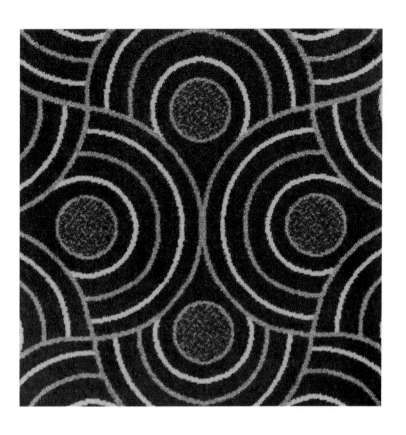

Renaissance Amsterdam Hotel, Amsterdam, Netherlands

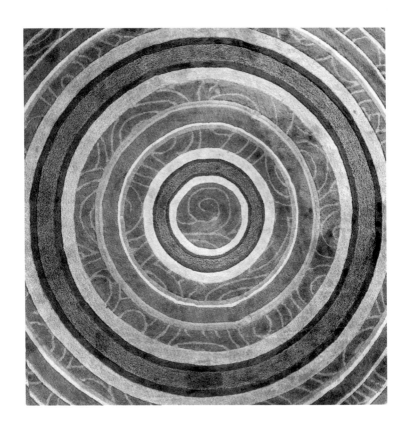

Renaissance Washington, DC Downtown Hotel, Washington DC, USA

This looks like the top view of
a mountain. I've flown over Japan
countless times, and one of the joys of flying
around the island nation is when you spot
Mount Fuji towering above the clouds.
A few of my co-workers have climbed Fuji.
I'll stick with the cockpit view.

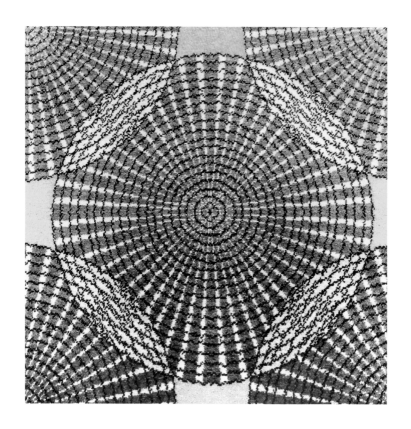

Nagoya Marriott, Nagoya, Japan

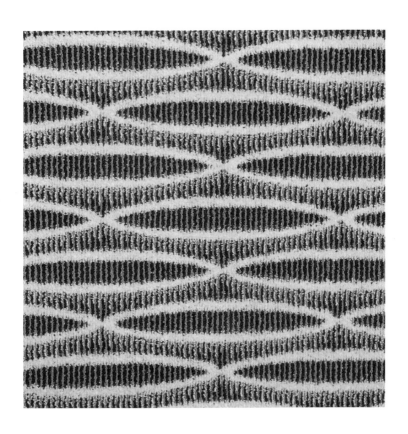

Washington Dulles Marriott Suites, Herndon VA, USA

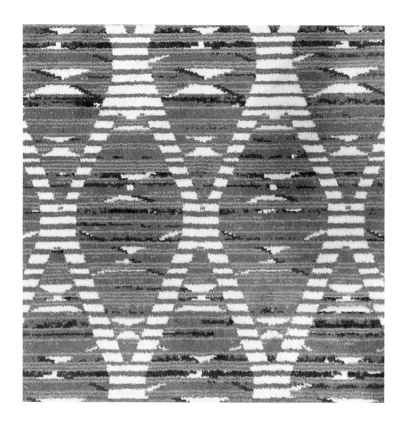

Cologne Marriott, Cologne, Germany

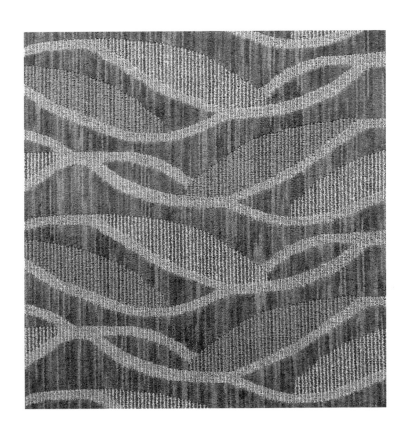

Hilton Narita Airport, Narita, Japan

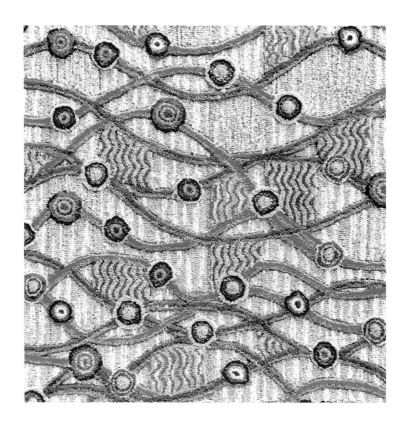

JW Marriott Desert Springs Resort & Spa, Palm Desert CA, USA

When I see the red line, I think river.
The other lines represent city blocks.
It reminds me of when I'm flying over a city,
London perhaps, as this carpet is found
in the Heathrow Renaissance. Look,
I can see my favourite pub, The Grenadier,
near Hyde Park.

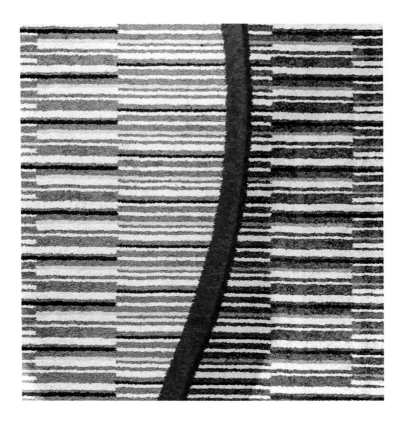

Renaissance London Heathrow Hotel, London, UK

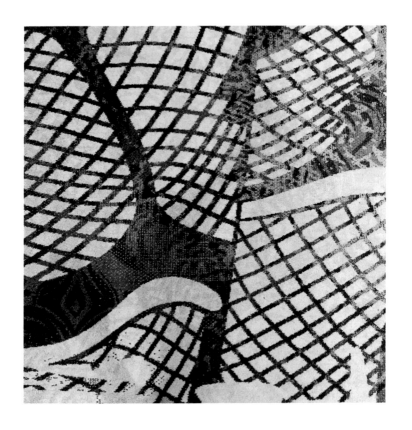

The Cosmopolitan of Las Vegas, Las Vegas NV, USA

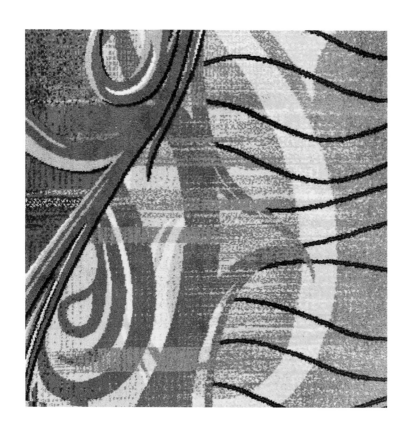

Boston Marriott Peabody, Boston MA, USA

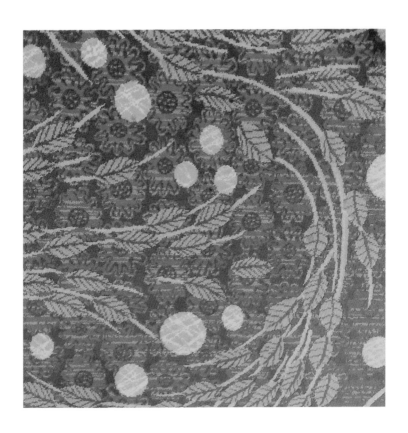

Courtyard by Marriott Dallas Allen, Allen TX, USA

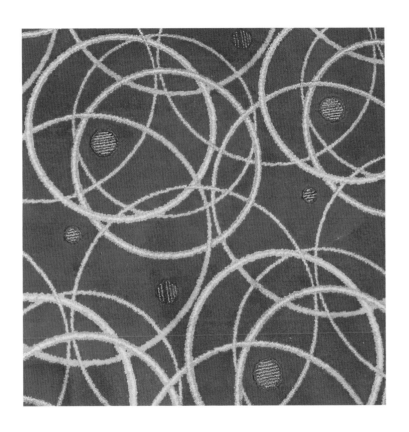

Renaissance Amsterdam Hotel, Amsterdam, Netherlands

This pattern is straight out of a 1980s MTV video for me. I can hear the electric drum machine and the five-note melody on the keytar. The stop-motion effects in the video seemed impressive at the time but weeks later I realised the annoying, soul-crushing melody was still stuck in my brain.

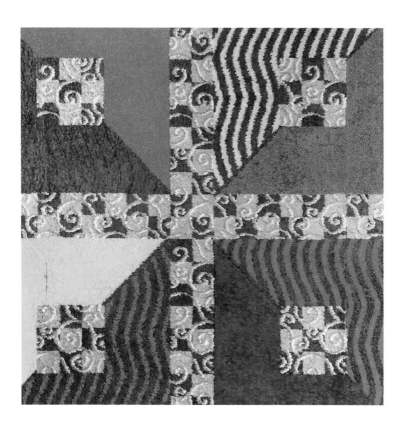

Long Beach Marriott, Long Beach CA, USA

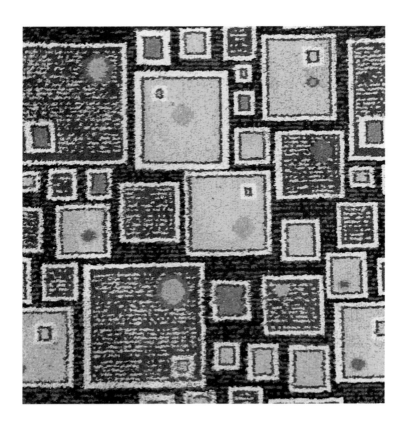

Marriott Riverfront Savannah, Savannah GA, USA

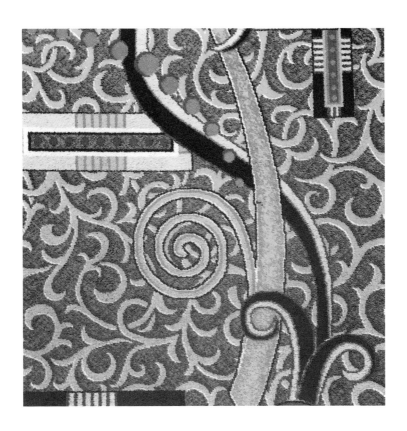

Ann Arbor Marriott Ypsilanti at Eagle Crest, Ypsilanti MI, USA

There is a lot going on in this design. Boxes, lines, swirls... all the activity makes me a little uneasy. I'm not saying it's a bad design, but it reminds me of an art project I did in the fourth grade. It started out OK but then I kept adding 'stuff'. The teacher studied it then took a long look at me. I'll never forget that look.

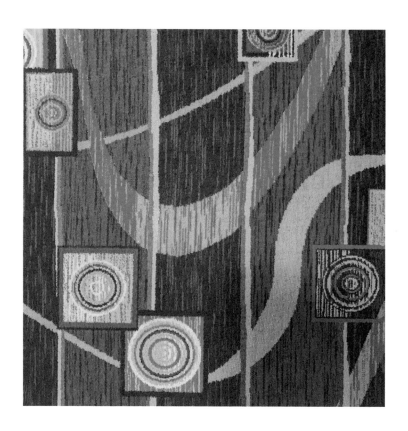

JW Marriott Desert Springs Resort & Spa, Palm Desert CA, USA

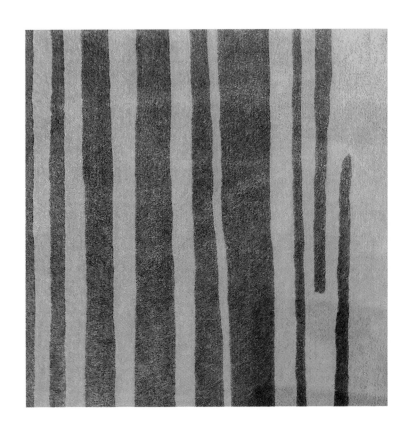

Aloft Plano, Plano TX, USA

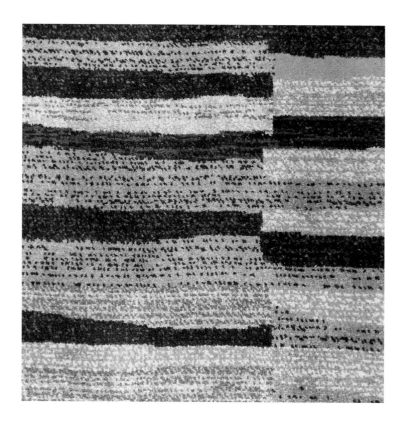

Fairfield Inn & Suites Springfield Holyoke, Holyoke MA USA

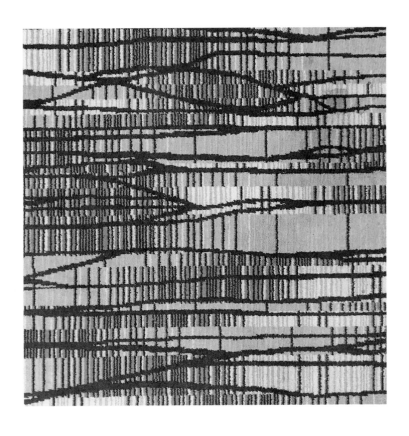

SpringHill Suites by Marriott Savannah Airport, Savannah GA, USA

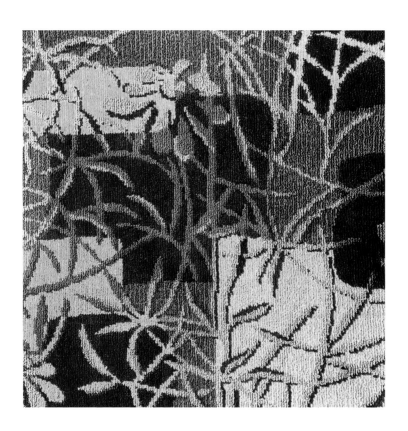

JW Marriott Hotel Beijing, Beijing, China

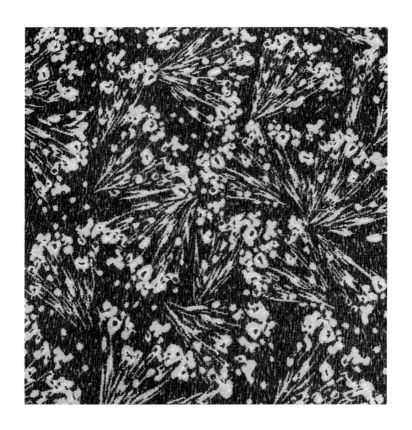

The Westin Wilmington, Wilmington DE, USA

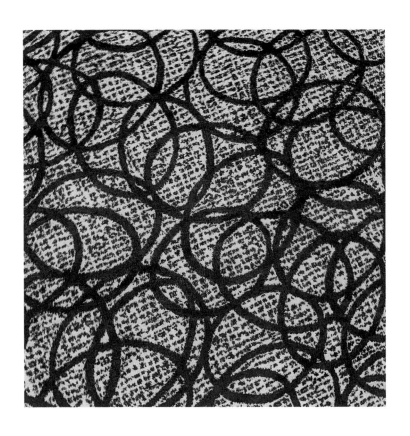

Sheraton Córdoba Hotel, Córdoba, Argentina

I get a Transformers vibe from this carpet in the Nagoya Marriott. Being that this is in Japan, I wouldn't be surprised if the whole hotel building isn't a robot waiting to turn into a fire-breathing beast. But maybe that's just me.

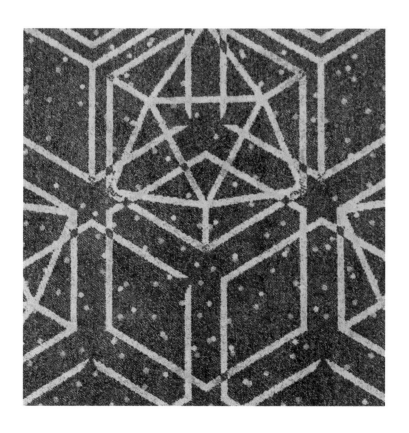

Nagoya Marriott, Nagoya, Japan

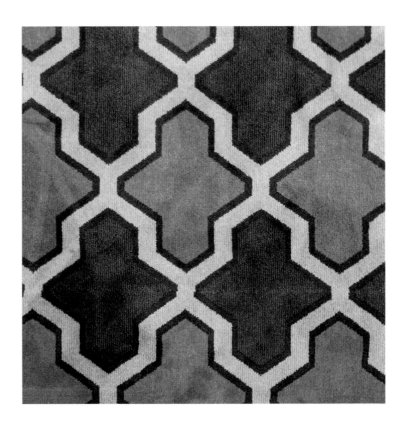

Renaissance Washington, DC Downtown Hotel, Washington DC, USA

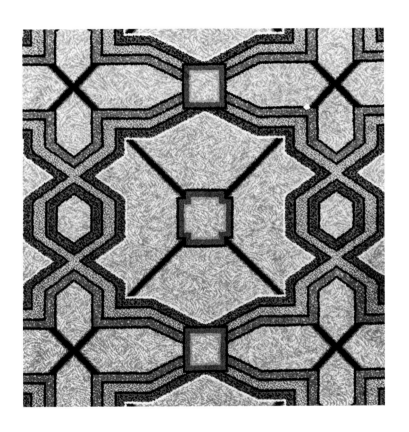

The Adolphus Hotel, Dallas TX, USA

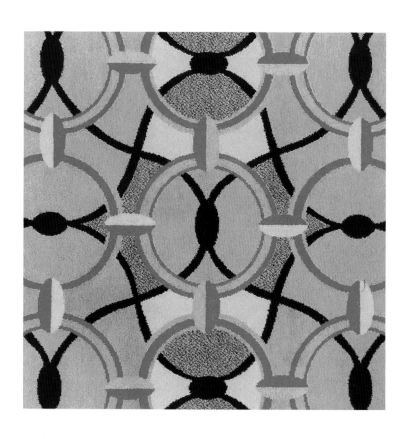

Marriott Hotel & Golf Club, Fort Worth TX, USA

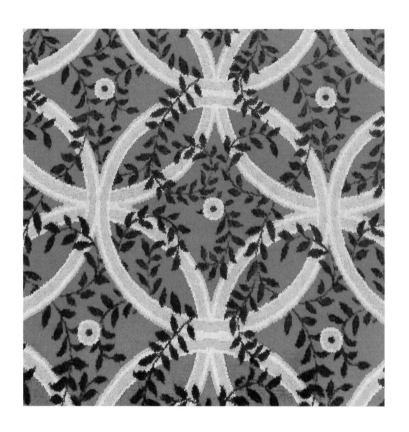

Renaissance Amsterdam Hotel, Amsterdam, Netherlands

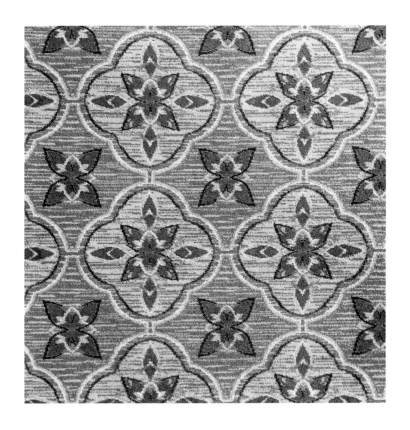

JW Marriott Hotel Beijing, Beijing, China

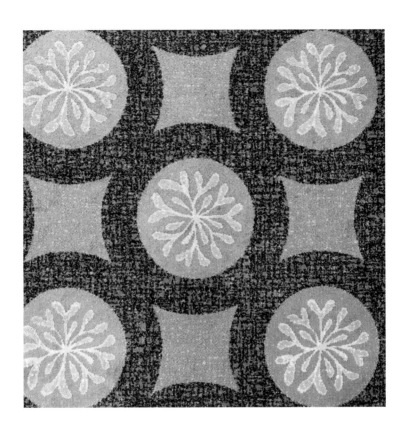

Nagoya Marriott, Nagoya, Japan

This strange design is from the lovely Park Hyatt in Tokyo. My job has me in Japan almost monthly. I sought out this hotel because it was featured in one of my favourite movies, *Lost in Translation*. The movie nailed what it feels like to be a westerner in Japan.

Park Hyatt, Tokyo, Japan

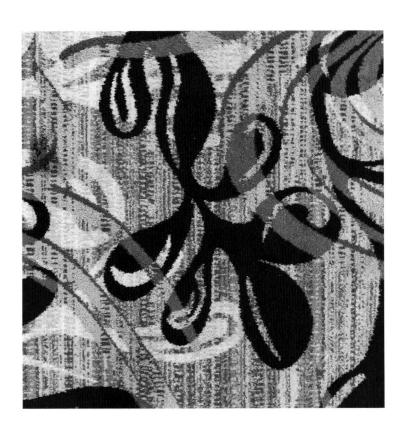

Marriott Riverfront Savannah, Savannah GA, USA

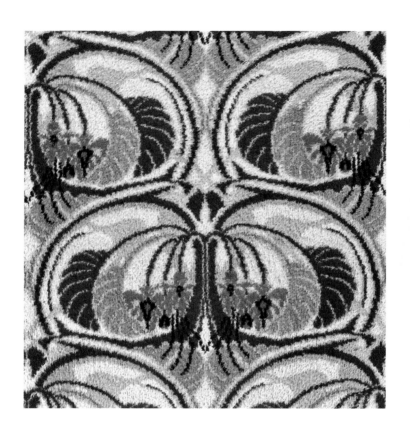

Nagoya Marriott, Nagoya, Japan

Marriott Riverfront Savannah, Savannah GA, USA

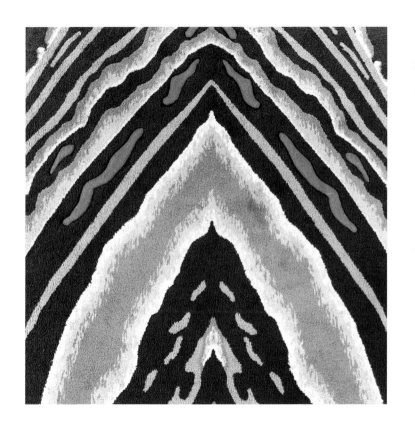

Marriott Hotel & Golf Club, Fort Worth TX, USA

I dare anybody to look at this carpet design
and not think of reproduction.

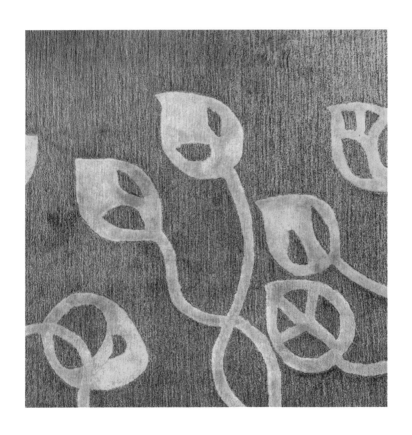

Marriott's Grand Chateau, Las Vegas NV, USA

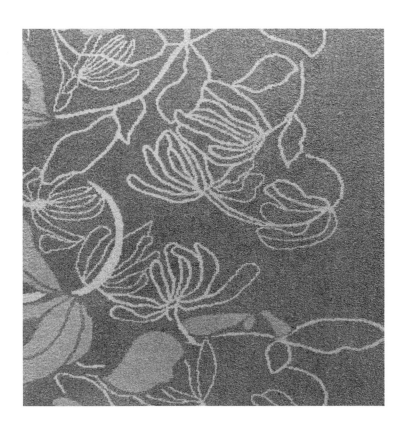

Guangzhou Marriott Hotel, Guangzhou, China

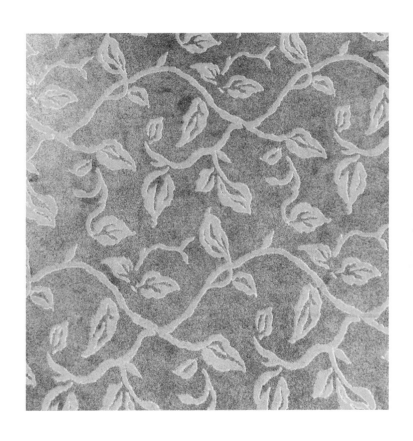

Crowne Plaza Hannover, Hannover, Germany

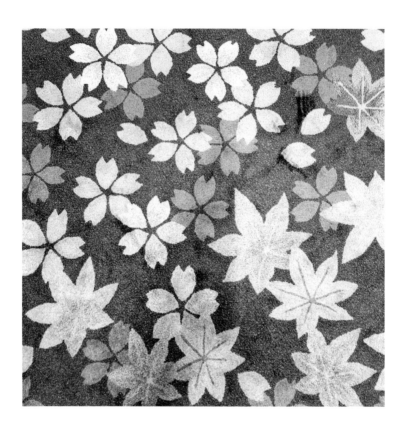

Courtyard by Marriott Tokyo Ginza, Tokyo, Japan

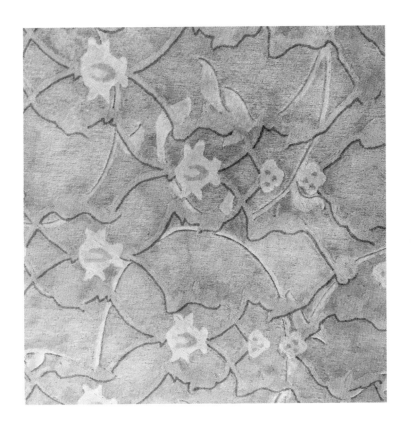

The Ritz-Carlton Tianjin, Tianjin, China

People often ask me which is my favourite carpet. I don't spend a lot of time ranking them but this Pink Floyd–esque pattern is probably number one. I think I had that album in vinyl — not in a hipster way, but in a 'that's all there was' way.

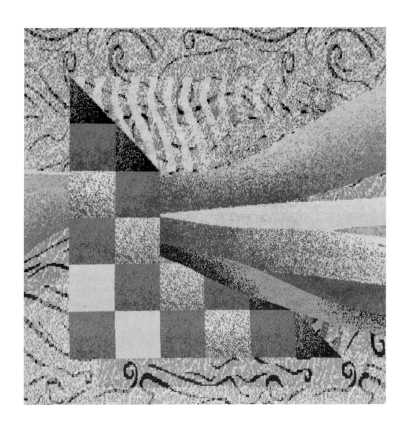

Long Beach Marriott, Long Beach CA, USA

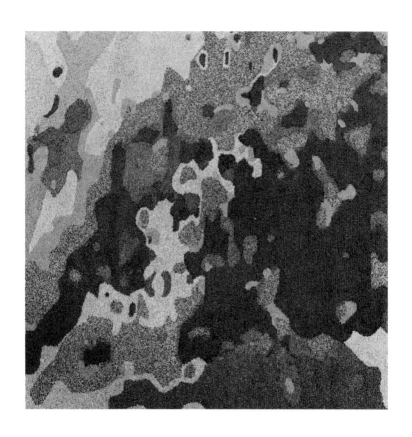

The Westin Detroit Metropolitan Airport, Detroit MI, USA

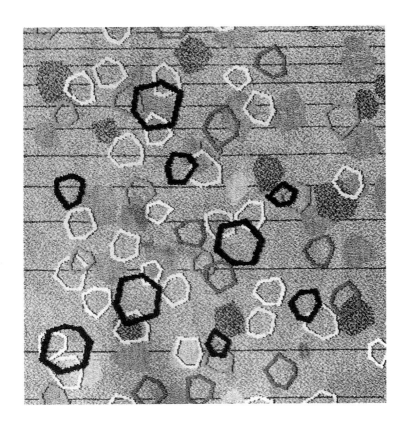

Courtyard by Marriott Hot Springs, Hot Springs AR, USA

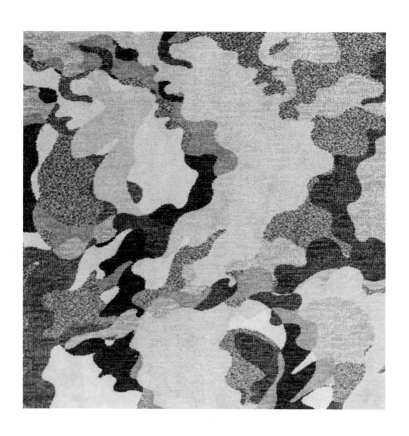

The Cosmopolitan of Las Vegas, Las Vegas NV, USA

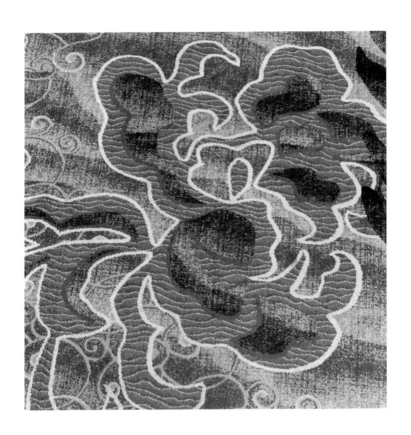

Guangzhou Marriott Hotel, Guangzhou, China

Descending into Las Vegas is always interesting. I love the way the gaudy city contrasts with the surrounding bleak desert. Something in this carpet reminds me of the approach.

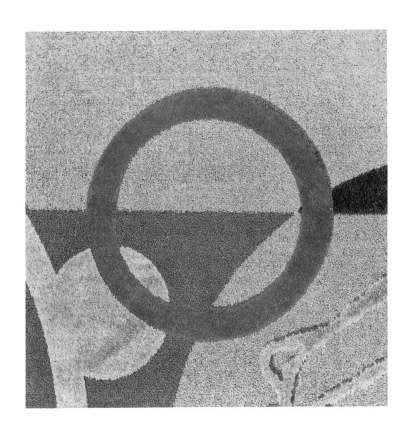

Marriott's Grand Chateau, Las Vegas NV, USA

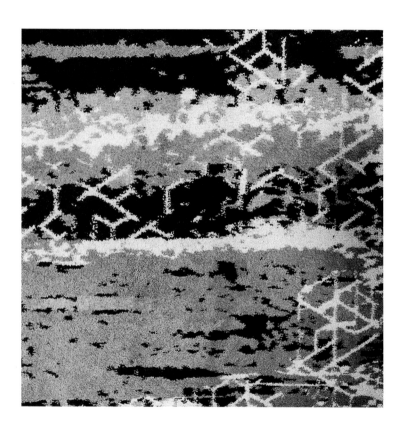

LAX Marriott, Los Angeles CA, USA

L'Hermitage Gantois, Lille, France

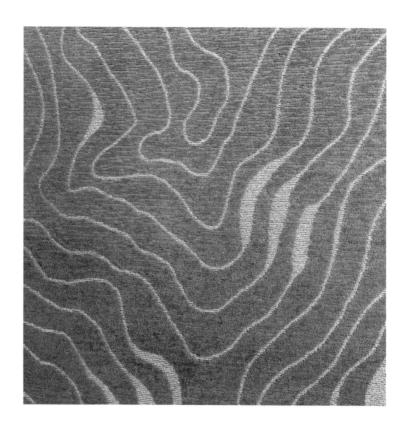

Detroit Metro Airport Marriott, Romulus MI, USA

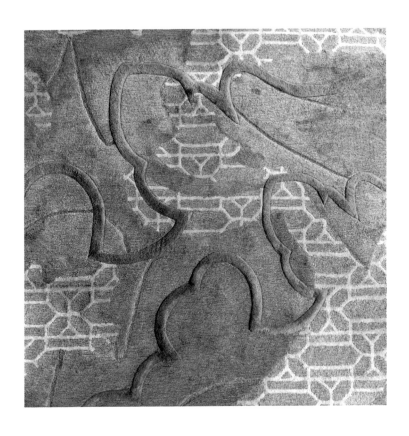

The Westin San Jose, San Jose CA, USA

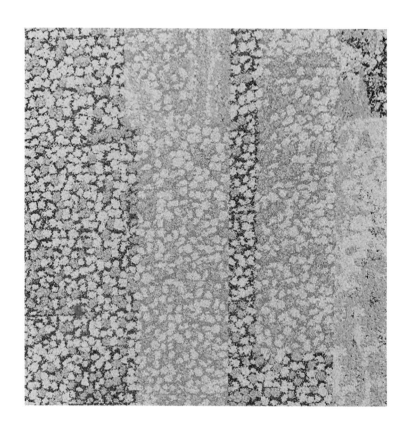

Courtyard by Marriott Fort Smith Downtown, Fort Smith AR, USA

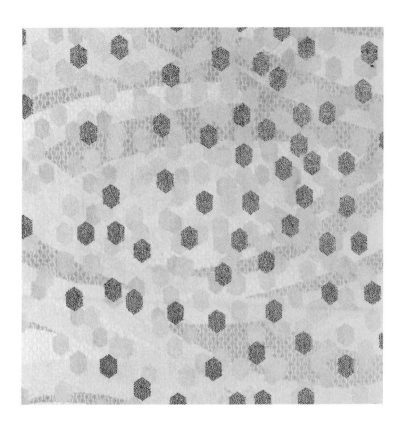

Renaissance Las Vegas Hotel, Las Vegas NV, USA

I see hamburgers in this carpet.
I like sushi as much as the next guy but
after staying in Japan so much I often
crave food from home. I catch a lot of flack
from my colleagues, but my favourite
place to eat in Nagoya is a western sports bar
called Shooters. Don't judge me until
you've tried their hamburgers.

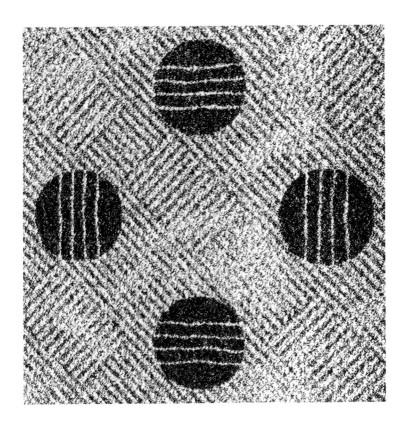

Nagoya Marriott, Nagoya, Japan

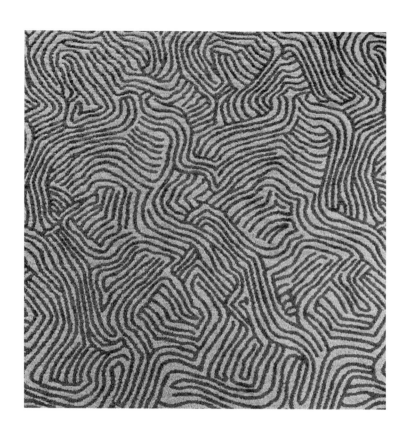

The Westin Detroit Metropolitan Airport, Detroit MI, USA

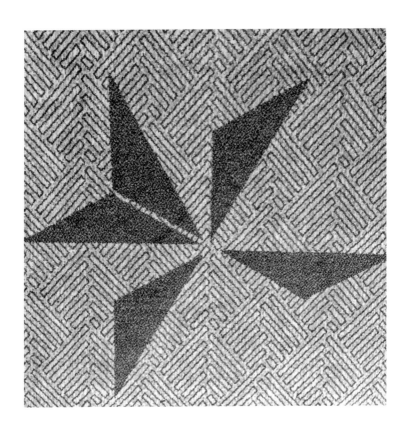

JW Marriott Austin, Austin TX, USA

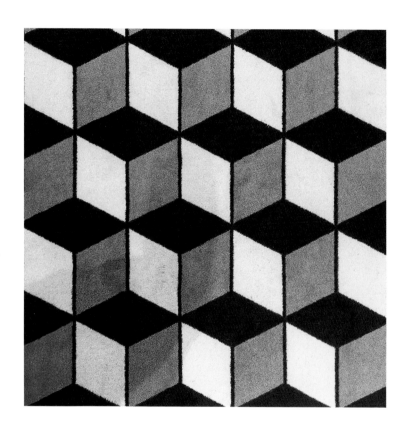

Adriana Hvar Spa Hotel, Hvar, Croatia

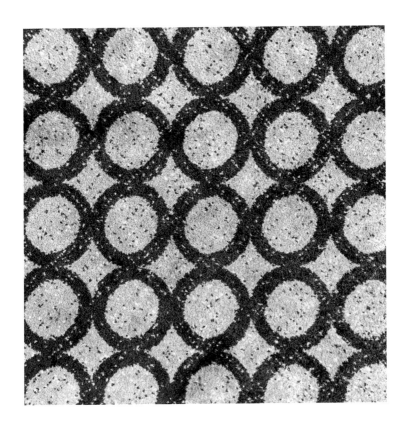

Nagoya Marriott, Nagoya, Japan

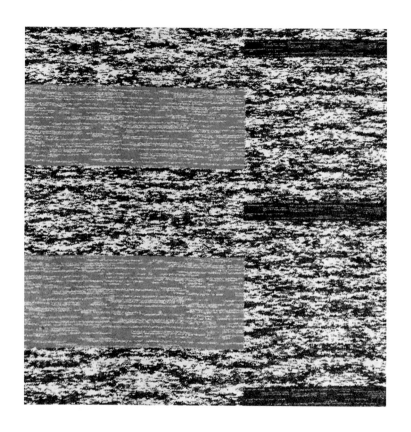

Embassy Suites by Hilton Dallas Love Field, Dallas, TX USA

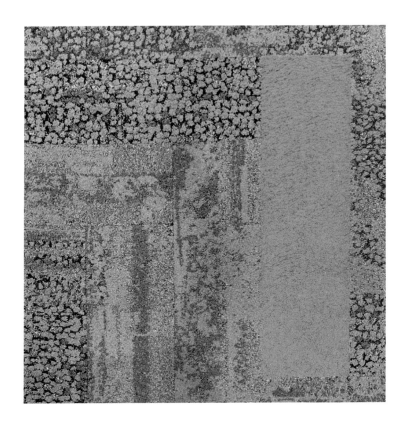

Courtyard by Marriott Tokyo Ginza, Tokyo, Japan

In this carpet I see a flock of bats
(Flock? Herd? Gaggle? Murder?) which is
appropriate as Austin is home to
a zillion of these creatures who make their
summer home below one of the
downtown river bridges. At sunset you
can watch them depart en masse.

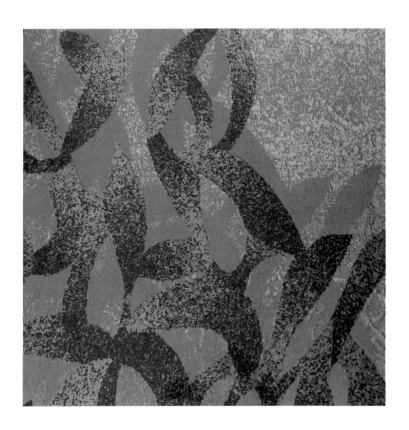

Residence Inn Austin University, Austin TX, USA

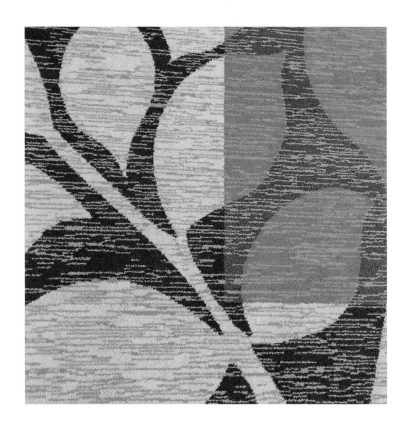

Residence Inn Austin University, Austin TX, USA

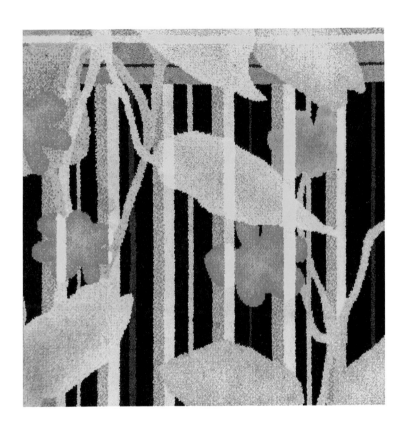

Fairfield Inn & Suites Austin North, Austin TX, USA

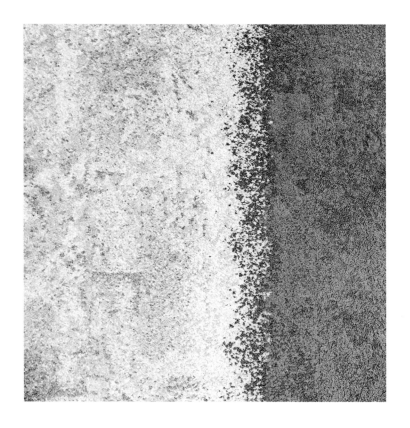

Element Austin Downtown, Austin TX, USA

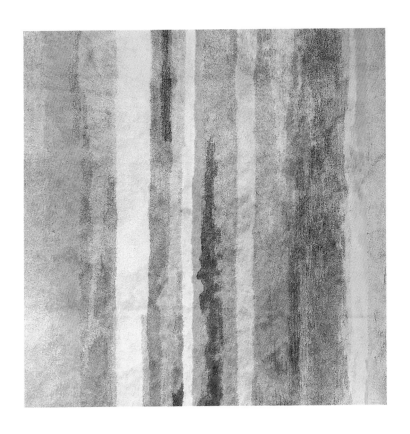

Narita Hilton, Narita, Japan

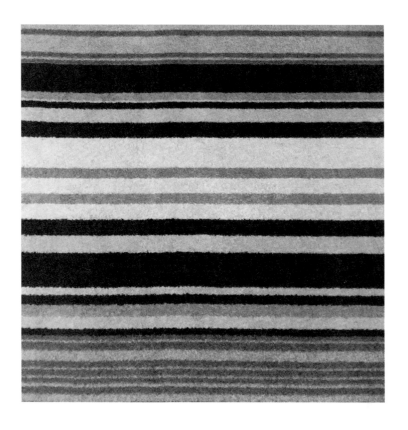

Renaissance Washington, DC Downtown Hotel, Washington DC, USA

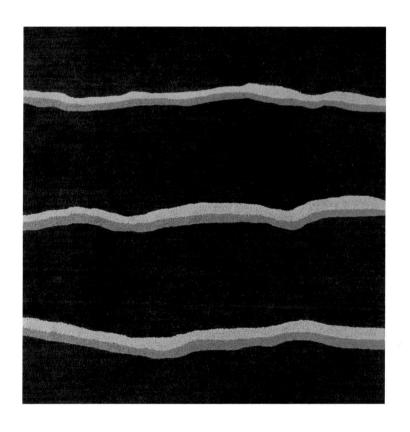

Fremont Marriott Silicon Valley, Fremont CA, USA

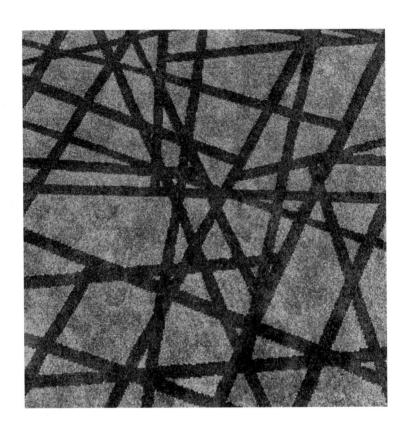

Courtyard by Marriott Tokyo Ginza, Tokyo, Japan

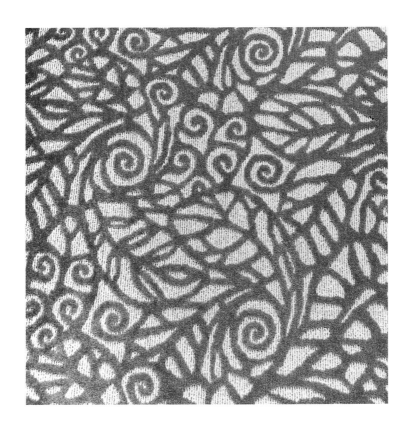

Marriott Cincinnati Airport, Cincinnati OH, USA

This 3D-looking woven design reminds
me of the obnoxious highways in Los Angeles.
Overpasses, underpasses — take the wrong
exit and you end up in Tijuana, Mexico instead of
Hollywood. (Ask me how I know.) While the
circles may seem like serene islands of calm,
the reddish colour denotes the intensifying rage
of the drivers trapped on the unending
Möbius strip of LA highways.

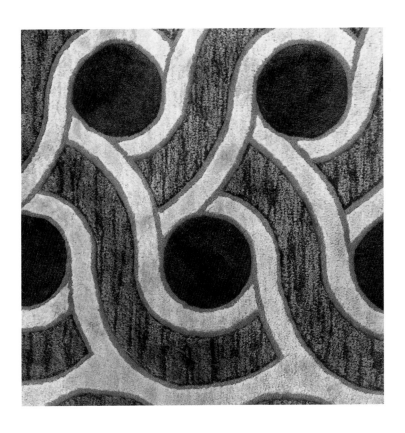

Renaissance Washington, DC Downtown Hotel, Washington DC, USA

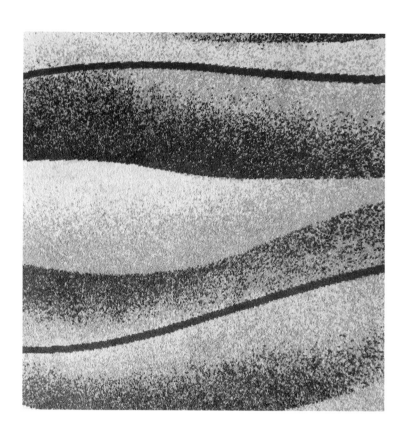

Munich Airport Marriott, Munich, Germany

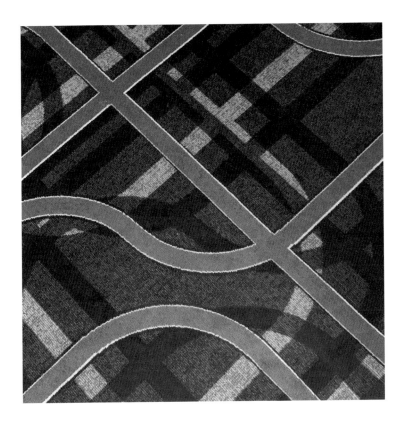

Aria Resort & Casino, Las Vegas NV, USA

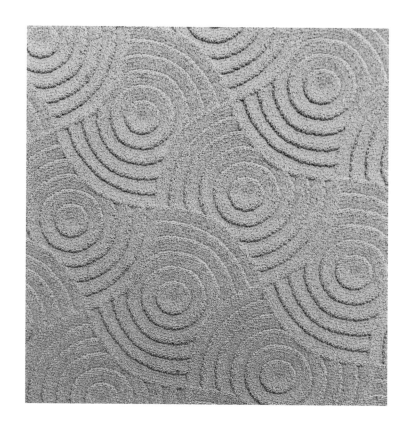

JW Marriott Hotel Beijing, Beijing, China

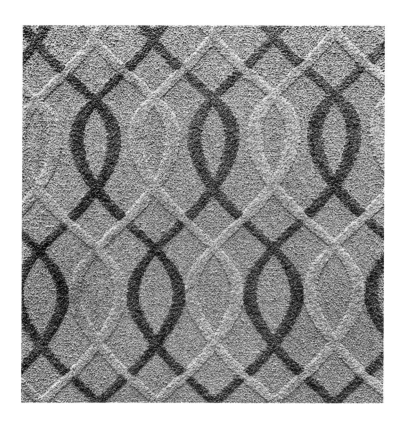

Sheraton Palo Alto, Palo Alto CA, USA

This carpet looks like somebody spilled a large bowl of ramen on the floor. That makes me sad, I love ramen. My favourite ramen restaurant is located in Narita, and I'd bet every aviation crewmember who lays over there knows about Ramen Bayashi. If you find yourself in Narita, seek out this place and order the chilli pepper soup, gyoza and a large Asahi.

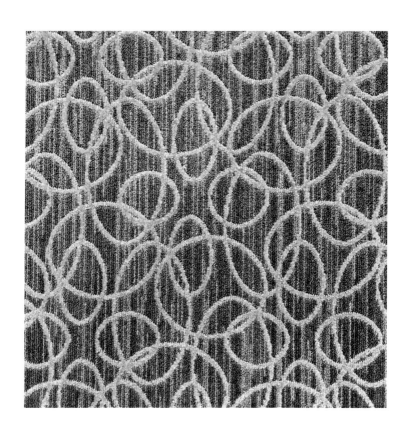

Narita Hilton, Narita, Japan

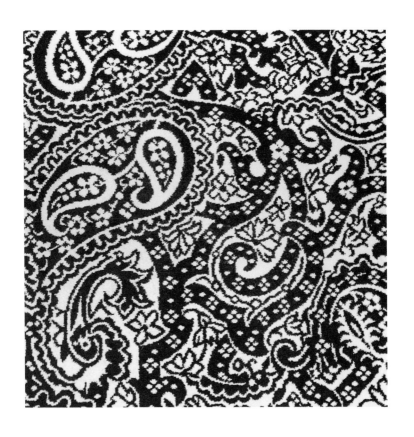

The Ritz-Carlton Tianjin, Tianjin, China

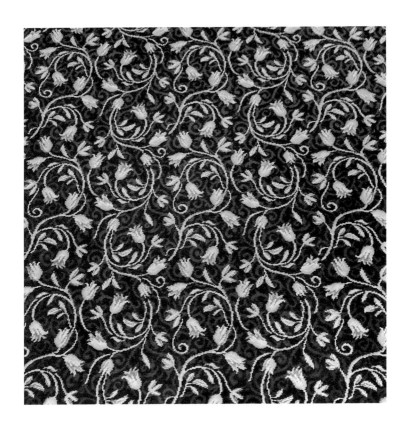

Nagoya Marriott, Nagoya, Japan

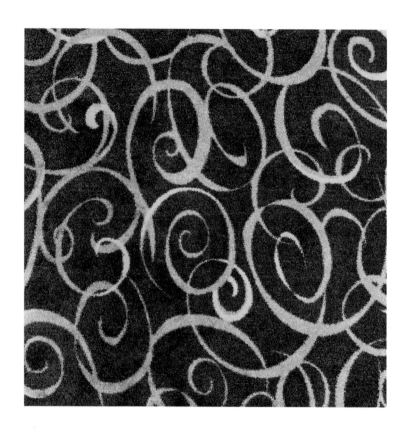

Carlo IV, The Dedica Anthology, Prague, Czech Republic

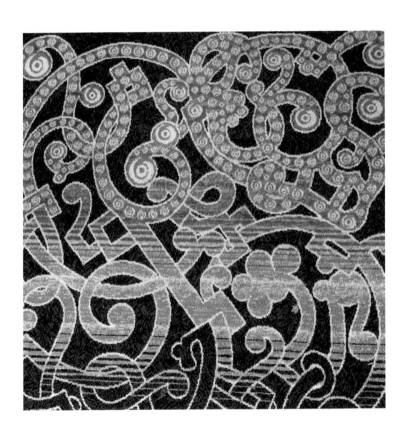

The Adolphus Hotel, Dallas TX, USA

This quirky pattern looks like the shimmering effect you see when a bit of gas or oil spills into sidewalk gutter water. As a kid I loved playing with water like this. I didn't know much about handling hazardous chemicals at the time.

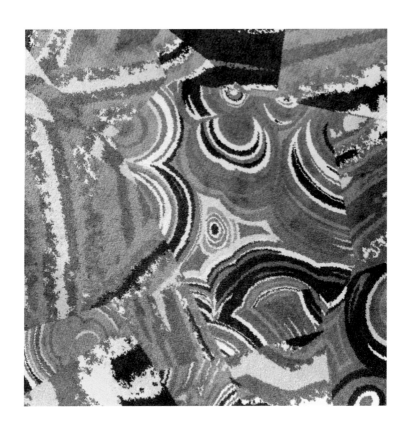

The Westin Detroit Metropolitan Airport, Detroit MI, USA

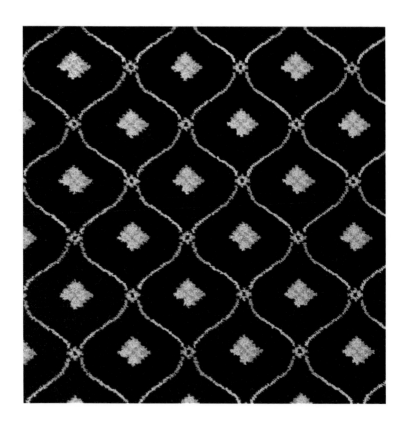

JW Marriott Hotel Beijing, Beijing, China

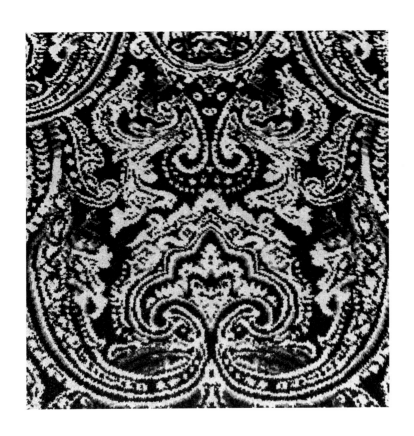

Warwick Melrose Hotel, Dallas TX, USA

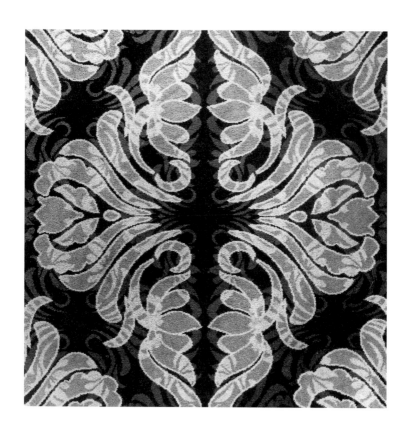

Nagoya Marriott, Nagoya, Japan

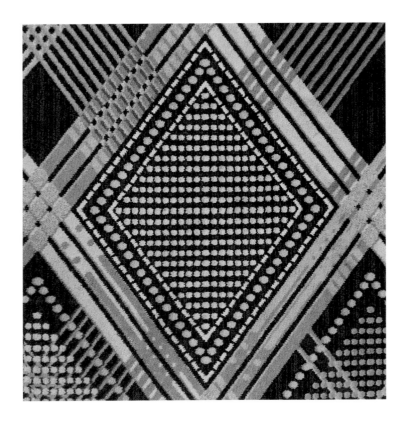

Marriott's Grand Chateau, Las Vegas NV, USA

I see an industrial gate in this geometric design. Where does it lead to and how do you open the door? Truthfully, I probably don't want to see what is on the other side. I'll stay on the safe side, order a beer at the hotel bar and enjoy the status quo. I like being comfortable. There's no way I'm opening that door.

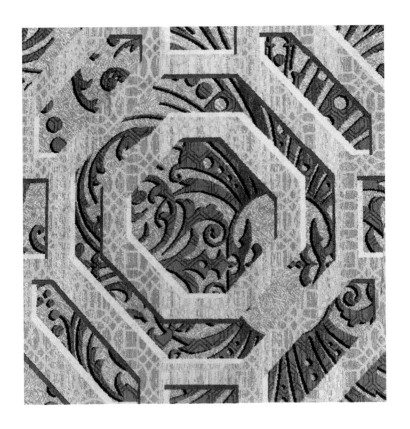

The Adolphus Hotel, Dallas TX, USA

Nagoya Marriott, Nagoya, Japan

The Adolphus Hotel, Dallas TX, USA

I get a strong sunset vibe from this carpet. I prefer sunsets over sunrises - the latter usually happen too early. When flying east through the night the sunrise is a quick process. It starts out calm but then turns into a nuclear fireball coming into the cockpit. This carpet pattern is calmer, like the sunset. It makes me want to take a nap.

Marriott's Grand Chateau, Las Vegas NV, USA

Hotel Carpets
First edition

Copyright © Hoxton Mini Press 2020
All rights reserved

Photography © Bill Young
Design by Daniele Roa
Copy-editing by Faith McAllister
Production by Anna De Pascale

A CIP catalogue record for this book
is available from the British Library

First published in the United Kingdom in 2020
by Hoxton Mini Press

ISBN 978-1-910566-74-9

Printed and bound by Ozgraf, Poland

To order books, collector's editions and prints please go to:
www.hoxtonminipress.com

FSC
www.fsc.org

MIX
Paper from
responsible sources
FSC® C002795